CANTICLE
OF THE SUN

THE SPIRIT OF
FRANCIS OF ASSISI

CALLIGRAPHY BY
FRANK MISSANT

SHAMBHALA
Boston & London
2002

SHAMBHALA PUBLICATIONS, INC.
Horticultural Hall
300 Massachusetts Avenue
Boston, Massachusetts 02115
www.shambhala.com

Collection directed by Jean Mouttapa and Valérie Menanteau
Photography by Sylvie Durand
Layout Design by Céline Julien

9 8 7 6 5 4 3 2 1

First Shambhala Edition
Printed in France

⊗ This edition is printed on acid-free paper that meets the American
National Standards Institute Z39.48 Standard.

Distributed in the United States by Random House, Inc.,
and in Canada by Random House of Canada Ltd

LIBRARY OF CONGRESS CATALOGING-IN-PUBLICATION DATA

Francis, of Assisi, 1182–1226.
 [Cantique des creatures. English]
 Canticle of the sun/Francis of Assisi; calligraphy by
 Frank Missant.—1st Shambhala ed.
 p.cm. — (Shambhala Calligraphy)
 ISBN 1 57062-980-3 (alk. paper)
 1. Nature—Religious aspects—Christianity.
 I. Title. II. Series.

BV489.F74C3713 2002
242'.72—dc21 2002017665

Altissimu

FRANCIS OF ASSISI was a great poet and at the same time a great saint. As an authentic minstrel of God, he danced, sang, and recited poetry in order to give honor to the Most High and to convert whomever he met along the way.

In stages, from the autumn of 1225 until October 3, 1226, the date of his death, Francis composed his celebrated "Canticle of the Creatures," also known as "Canticle of the Sun." Without a musical instrument, without parchment, he improvised this song, which was the very first masterpiece of Italian literature. Out of a spirit of poverty and out of love for the most simple of his brothers, he put aside Latin, the language of the educated and of the clerics, to give birth to a new kind of poetry in his mother tongue.

According to tradition, it was after a night of torment, spent in a hut near San Damiano, just below Assisi, that he created this song of perfect joy.

After the first two stanzas, devoted entirely to celebrating the greatness and infinite goodness of God, the "Canticle of the Sun" proper begins. Francis repeats *Laudato si', mi' Signore* in spellbinding rhythm at the

beginning of each stanza and successively invokes the sun, the moon, and the stars, the wind, water, fire, and earth. Breaking with the tradition that isolates humanity from the rest of creation, the poet addresses each creature affectionately as brother or sister. Francis bore a fraternal love toward the reality that surrounded him. Thus he was far from sharing the contempt for the world often professed by his contemporaries. All the same, he was not a pantheist: in his canticle, only God is praised, even if his creatures take an active part in the celebration of their Creator.

Each time he sings *Laudato si', mi' Signore*, Francis introduces one of the creatures by making use of the preposition *per*. What should we understand by this? That the Creator should be praised through his creatures, because of his creatures, or even by the creatures themselves? Francis' language is imprecise but extremely suggestive. The great family that makes up creation is at once the locus of and the reason for the praises. It itself is the choir that is called upon to sing the blessings of the Most High.

The tenderness the *poverello* bore toward his brothers and sisters can be seen in his use of numerous qualifying adjectives: Brother Sun is *bellu* and *radiante;* Sister Water is *utile, humile, pretiosa*, and *casta*. These qualities are not the autonomous properties of the creatures themselves but rather serve to justify the movement of praise consecrated to God.

The next-to-last stanza, a hymn to forgiveness and to

peace, was added in July of 1226 especially for the podesta and the bishop of Assisi, the representatives of civil and religious power in the city, in order to put an end to their fratricidal conflict. Here one sees Francis' sense of engagement—until the end he remained an apostle of peace.

The last stanza, composed shortly before his passing, where he refers to death as "our sister," is a vivid testimony of faith and hope. Here Francis, in accordance with tradition, distinguishes the death of the body and the "second death," the latter being that of the soul if it is damned. Nevertheless, taking the tone of the Beatitudes, Francis ends with the idea of forgiveness and salvation. These last words are yet another call to praise God in all humility—the essential Franciscan virtue.

After the poet's death, numerous texts appeared recalling his deeds and extolling his merits. All these accounts were composed in Latin, and it was not until the fourteenth century that an anonymous hand produced a series of fifty-three *fioretti* ("little flowers") in Italian. Each of these describes an episode, henceforth legendary, in the life of the *poverello*. Several excerpts from this collection have been included in this book, ones in which Francis appears as the loving friend of creatures and particularly of animals. In the spirit of the "Canticle of the Sun," these *fioretti* provide a fresh, living testimony to the love Francis had for the world and, through it, for its Creator.

Michel Feuillet

CANTICLE OF THE SUN

Most high, all powerful, good Lord,
Thine are the praises,
The glory and the honor,
And all blessing.
To Thee alone, Most High, are they due
And no man is worthy
To utter Thy name.

Altissimu
onnipotente
bon Signore
tue so' le laude
la gloria
e l'honore
et onne
benedictione

Be praised, Thou, my Lord,
With all Thy creatures,
Especially my lord the Sun:
He gives us the day
And he is beautiful and shines
With great splendor.
Of Thee, Most High, he is the sign.

audato · sie mi'
ignore · cum · tue
e le tue · creature
petialmente mes
or lo · frate · sole ·
o quale iorno · a
llumini · noi per
ui: et ellu · è bel
u · e radiante · cū
rande · splendore
de · te · altissimo ·
orta significatio
e: ad · te · solo · al
imo · se konfano

Be praised, Thou, my Lord,
For Sister Moon and the stars:
In the sky Thou hast created them,
Clear, precious, and beautiful.

laudato
sie
mí Signore
per
le·stelle

Laudato
si' per
frate
vento
et per
l'aere

Be praised, Thou, my Lord,
For Brother Wind
And for the air and the clouds
And for the sky serene and all the weather
Through which Thou givest sustenance
To Thy creatures.

Be praised, Thou, my Lord,
For Sister Water
Who is very useful and humble
And precious and chaste.

Laudato si', mi' Signore per frate focu.

B e praised, Thou, my Lord,
For Brother Fire
By which Thou lightest the night:
And he is beautiful and joyous
And hardy and strong.

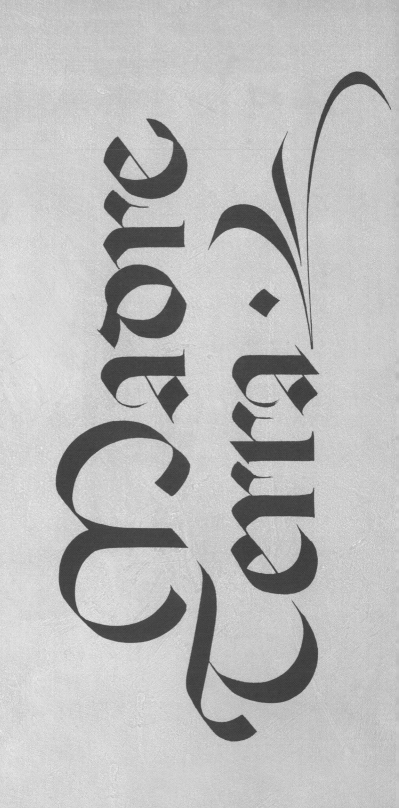

Be praised, Thou, my Lord,
For our sister and mother, the earth,
Who sustains and nurtures us:
She brings forth the various fruits
With colored flowers and greenery.

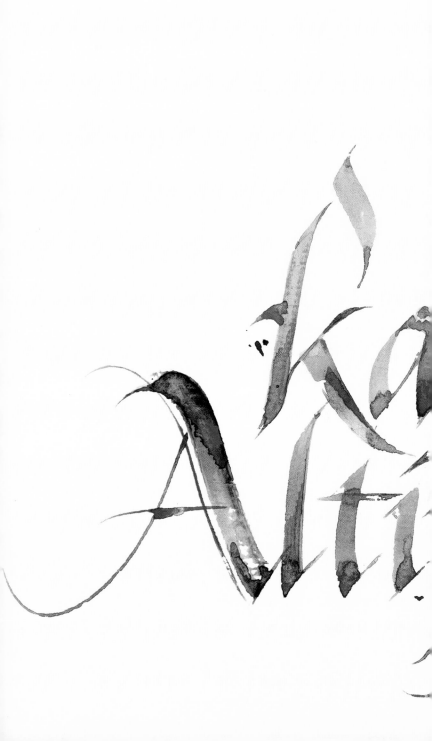

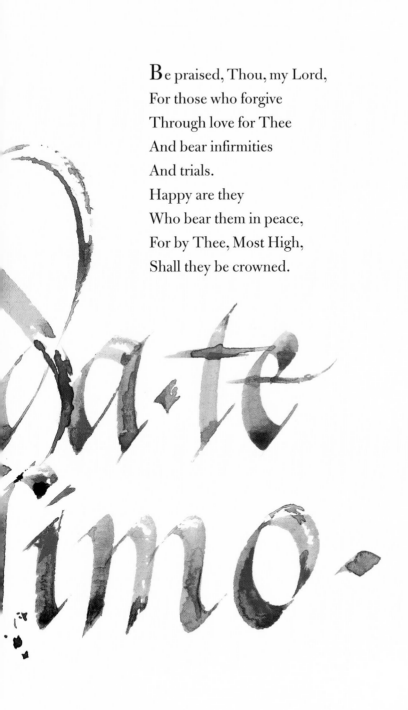

Be praised, Thou, my Lord,
For those who forgive
Through love for Thee
And bear infirmities
And trials.
Happy are they
Who bear them in peace,
For by Thee, Most High,
Shall they be crowned.

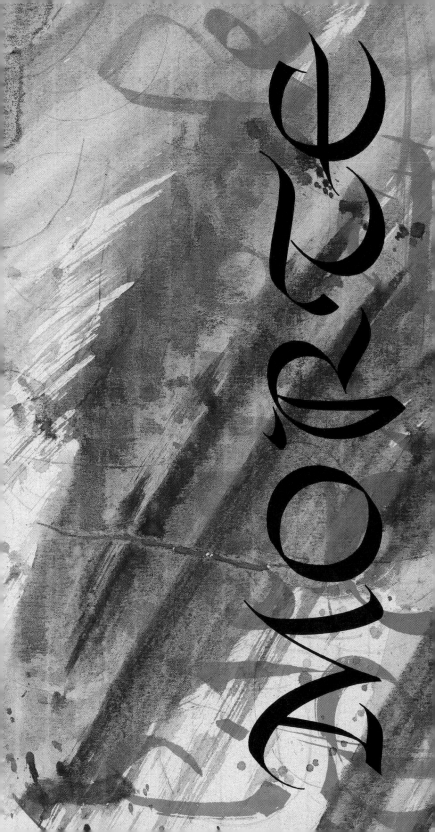

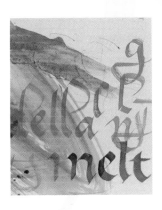

Be praised, Thou, my Lord,
For our sister bodily death,
From which no living human can escape:
Woe to them who die
In mortal sin.
Happy are they whom she finds
Performing Thy holy will,
For the second death will not harm them.

Lauda-

e·benedicete

et·ren

e·ferviat

cum·grand

Praise and bless my Lord
And thank Him
And serve Him with great humility.

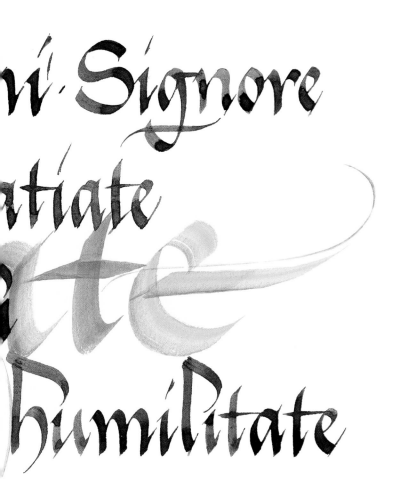

THE SERMON TO THE BIRDS

Going his way with the fervor that was his, Saint Francis lifted his eyes and saw some trees near the road in which there was a nearly infinite multitude of birds. He was struck with the wonder of this and said to his companions, "Wait for me on the road, I'm going to go preach to my brothers the birds."

io · Andrò
a · predicare
alle · mie
pirrocchie
& uccelli

ha dato
libertà di
volare in
ogni luogo

So Francis went into the field and began preaching to the birds who were on the ground. And immediately, the ones in the trees gathered around him, and all of them together remained without moving until Francis had finished preaching. And they even waited to depart until he had given them his blessing.

The substance of Francis' sermon was this: "My brothers, the birds, you are indebted to your Creator for many reasons. You should praise Him always and everywhere, for He has given you the freedom to fly to any place; for He has also provided you with double and triple clothing; and in addition to that, because He preserved your seed in Noah's Ark, so that your species would not disappear from the world. You are also indebted to Him for the element of air, which He has appointed for you.

minate ·

on · mietete

In addition to that, you neither sow nor reap, and God nourishes you, and He provides you with rivers and springs so that you can drink; He gives you the mountains and the valleys so that you can take refuge there, and the great trees so you can make your nests in them. And, even though you know neither how to spin nor to sew, God dresses you, you and your children. Think how much the Creator must love you to grant you so many kindnesses."

How Saint Francis Tamed the Wild Turtledoves

One day a young man had captured a large number of turtledoves and he was carrying them off to sell. Francis, who always showed a particular tenderness toward harmless animals, encountered the young man, and looking at the turtledoves with pity, said to him: "O, good young man, I beg you to give them to me, so that such innocent birds, to which chaste, humble, and pious souls are compared in the Holy Scriptures, do not fall into the hands of cruel people who might kill them."

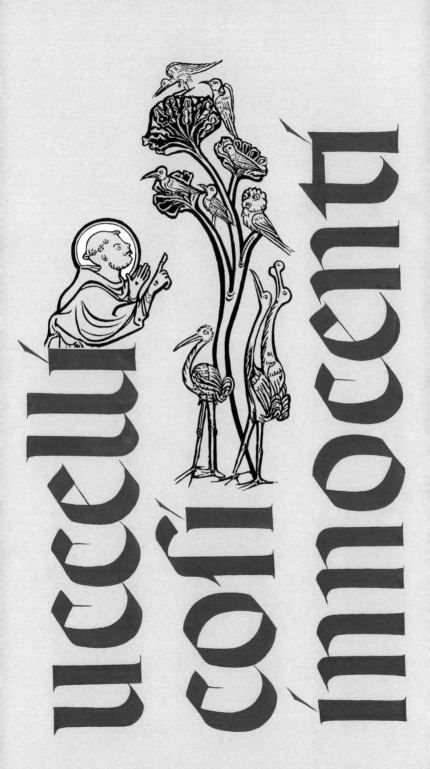

Sirocchie Mie

Immediately, the young man, inspired by God, gave them all to Francis. Francis, clutching them to his breast, began speaking to them sweetly: "O, my sisters, simple, innocent, and chaste turtledoves, why did you let yourselves be captured? Now I am going to rescue you from death and make nests for you so that you can be fruitful and multiply according to the commandment of your Creator."

e·va Santo
Francesco
e·a tutte
—fece·nido

Francis carried them away with him and made nests for them all. And they used them and went about laying and hatching eggs in view of Francis and the other brothers. The birds stayed there and lived with them, displaying as much familiarity toward them as if they had been hens the brothers had always fed. The birds did not leave until Francis gave them leave and granted them his blessing.

The Very Holy Miracle Performed by Francis When He Converted the Very Fierce Wolf of Gubbio

During the time when Francis was staying in the town of Gubbio, there appeared in the surrounding country a very large, fierce and terrible wolf, who devoured not only animals but also people. Thus the inhabitants lived in fear, especially when the wolf came near the town. Whoever left the town carried arms as though going to battle. But in spite of this, a person who met the wolf on his own was unable to defend himself from it. Matters reached the point where, out of fear of the wolf, no one any longer dared go outside the confines of the town.

un·lupo
grandissimo
terribile
e·feroce

For this reason, Francis, taking pity on the people of this town, decided to go out and meet the wolf, despite the vigorous warnings of the town dwellers. Making the sign of the Holy Cross, he passed through the city gate with his companions, placing his entire trust in God. Although the others were hesitant to go further, Francis took the road that led to the wolf's territory. And then, under the eyes of the town dwellers who had come in great numbers to see this miracle, the wolf rushed at Francis with its jaws agape.

il · segno
della
CROCE

Approaching the beast, Francis made the sign of the Cross. He called to it and spoke to it as follows: "Come here, Brother Wolf! In the name of Christ, I command you to do no harm, either to myself or to anyone else." At this moment a wondrous thing occurred. As soon as Francis made the sign of the Cross, the fearsome wolf closed its mouth and stopped running. And at Francis' command, it came and laid himself, as gently as a lamb, at his feet.

Then Francis spoke to him as follows: "Brother Wolf, you have wrought a great deal of harm in this district and you have committed many misdeeds, injuring and killing the creatures of God without His permission; and not only have you killed and devoured animals, but you have had the audacity to injure and kill human beings made in the image of God. For this reason, you deserve to be hung like the worst of robbers or the worst of murderers; everyone here is crying out and grumbling against you, and you are the enemy of the whole country. But as for me, Brother Wolf, I would seal the peace between you and all these people so that you no longer attack them and they forgive you all your past offenses. Neither men nor dogs will chase you anymore."

Promettimi tu questo

When these words had been said, the wolf
showed by movements of his body—his tail
and his ears—and by lowering his head that
he accepted what Francis had said and was
willing to abide by it. Then Francis said:
"Brother Wolf, since you are willing to
make the peace and respect it, I promise to
have the inhabitants of the town provide
you regularly with all the food you have
need of, to the point where you will no
longer suffer hunger. Because I know it has
been out of hunger that you have done all
this evil. But in consideration of my gaining
you this favor, I want you, Brother Wolf,
to promise me never to harm any human
being or any animal. Do you promise?"
By lowering his head, the wolf gave a clear
sign of his promise.

promessa

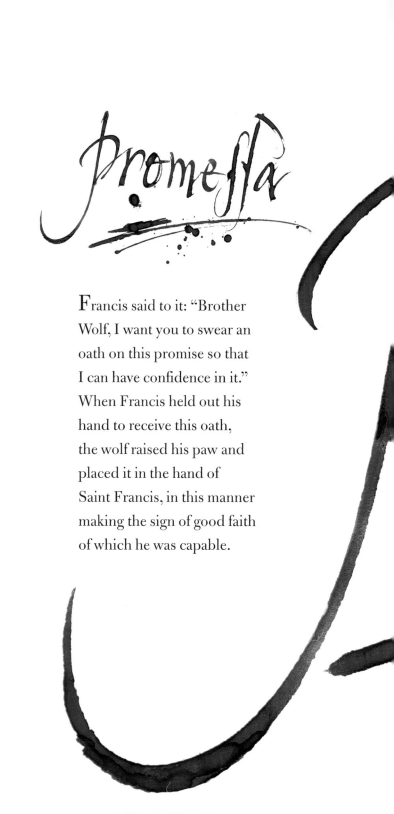

Francis said to it: "Brother Wolf, I want you to swear an oath on this promise so that I can have confidence in it." When Francis held out his hand to receive this oath, the wolf raised his paw and placed it in the hand of Saint Francis, in this manner making the sign of good faith of which he was capable.

il· lupo·

levo·

il· piè·

rito

·omanzi

Francis said to the people: "Hear me, my brothers! Brother Wolf, who is here before you, has promised me and sworn an oath to make peace with you and never to trouble you in any way whatsoever if you promise to give him what he needs. As for me, I will stand as his bondsman to guarantee that he will faithfully respect this pact of peace." Then all the people, with one voice, promised always to feed it. . . .

After this, the wolf lived for two years in Gubbio. It went from door to door and entered the houses familiarly, without ever doing harm to anyone or having any harm done to it. It was courteously fed by the people, and as it walked through the town and entered the houses, never did any dog bark at it.

Doppo · i · due ·

mori · d

cittadini ·

Finally, after two years, the wolf died of
old age, to the deep sorrow of the town
dwellers, because in seeing it move
about the town as a peaceful creature,
they had been better able to remember
the virtue and holiness of Francis.

v

e · f

ui · frate lupo · si
ecchiaia · di · che i
lto · si · dolsono · e · si
cordavano
glio · della virtù
ità · di · santo
Francesco ··

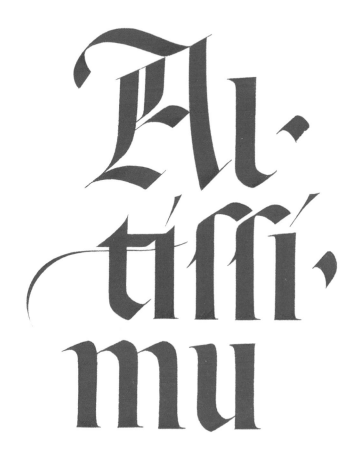

FRANK MISSANT

I was born in Tielt, a small Belgian town that was very caught up in cultural life. There I was steeped from my earliest childhood in a world in which craftsmanship occupied a central place. My father was a cabinet maker, my mother worked leather, my grandfather was a dressmaker, and one of my uncles was a restorer of fine armchairs. My interest in art was nurtured by this family circle and then later was spurred on to greater heights by my high school teachers. At the beginning of the twentieth century, certain Catholic priests in Flanders, who were discomfiting the ecclesiastical authorities with their reformist ideas, were removed from their positions and sent to Tielt. These worthy men, who were open to outside ideas and in possession of a critical spirit, not only provided their students with a classical education, such as is found in the study of Greek and Latin, but also an artistic one through classes in aesthetics. I still have the very clear memory from this period of one of my teachers who transmitted to me a love of literature and of works for the theater.

After my secondary studies, I went to the University of Gand with the intention of undertaking studies in law, but after a few months, I realized that my way was

quite a different one. The following year, I was accepted by the Academy of Fine Arts of Gand, from which I received a degree. I became a teacher of drawing and worked in particular with mentally handicapped children. Desiring to deepen my understanding of the pictorial arts, but also because I wanted to learn calligraphy, at the age of twenty-two I began taking evening courses with Jef Boudens. This Bruge artist, very well known in Belgium, was the only person who was teaching calligraphy in the seventies. He was the heritor of a great tradition.

Though it is neglected by the history of art, Western calligraphy had one of its most brilliant periods in the sixteenth and seventeeth centuries. During this period Flemish and Dutch masters succeeded one another in bringing this art to pinnacles of perfection seldom equaled since. Gerardus Mercator, a pioneer of this school in Flanders, published in 1540 one of the very first manuals on the Italian alphabets, the *Literarum latinarum.* His successor, Jocodus Hondius, and his sister Jacquemyne, who lived in Wakken, a village quite close to Tielt, also made their contribution toward establishing the art of beautiful writing as a legitimate and respectable one. As for Jan Van den Velde, the Low Countries' most famous calligrapher, he has left us a number of priceless masterpieces.

Though calligraphy is an art that does not necessarily require a solid foundation in drawing, it does require of calligraphers that they assimilate the basic principles of

the long tradition of which they are the heirs. For this reason the very first steps in calligraphy consist in working on the historical alphabets—the roman, the gothic, etc. Development from the simplest to the most complex of scripts is not something that can be taken for granted. The art of calligraphy is a total craft that requires years of apprenticeship with a teacher. For this reason, following the advice of my master, Jef Boudens, I left for France, for the town of Lure, to take a course in calligraphy. Each summer, cultural programs are presented in connection with annual conferences instituted there by the author Jean Giono and the typographer Maximilien Vox. Bernard Arin, master at the Scriptorium of Toulouse, conducted the training program I attended, and Jean-Claude Lamborot presented a workship on carving in stone. I was fascinated by the raw materials he used and I took this course, too. From this time on, I understood that, for me in my personal studies, calligraphy and stone carving were two parts of a single whole, which brought together the artistic and artisanal aspects of creation. After that, I went to Annonay in Ardèche, where I met Claude Mediavilla. Through his own double-edged training as both a painter and a calligrapher, this former professor at the Academy of Decorative Arts in Paris had devoted himself to bringing out the undiscovered qualities of the brush or pen stroke, particularly through his innovative work with color. Claude Mediavilla put the finish on the training I had received from Jef Boudens, even correcting certain movements I was mak-

ing that were causing me to produce false strokes.

False strokes are the main pitfall for apprentice calligraphers. This problem can only be remedied by study of the *ductus*, a Latin word that has its etymological origins in the word *digitus*, meaning finger. And there is another study that is of major importance in completing the training of the calligrapher: the study of paleography. This discipline, which is concerned with deciphering ancient scripts on perishable materials such as parchment or papyrus, sheds precious light on our history of writing. For this reason I took courses in this field at the University of Gand with a specialist on Flemish Burgundy, Professor Prevenier. Like any other art, calligraphy calls for theoretical background knowledge. In this case, not only is a knowledge of paleography required but also a knowledge of codicology. Codices (the plural of *codex*) are books composed of sheaves of parchment or paper; they are distinguished from scrolls, which are formed by sheets of parchment being rolled on a wooden dowel. In order to master the art of the intelligent stroke, one needs not only a practiced and proven gestural technique but also a body of knowledge related to the history of scripts and the history of ancient books. Once I had acquired this knowledge, I went about setting up on my own as a graphic artist specializing in posters and other logotypes.

The Middle Ages is one of the periods I am fascinated with. I am especially interested in the Cistercian movement that developed in the twelfth century around Bernard of Clairvaux. In contrast to the pomp and luxury made much of by the Abbot of Cluny, one of the demands made by this monk was renunciation of various forms of wealth. Poverty undergone as a monastic discipline, which was common to both the reformed Cistercian and Franciscan rules, brought about a profound change in the lives of Bernard and Francis, both of whom were sons of the privileged classes. The "Canticle of the Sun" by Saint Francis is marked by great delicacy and seems to me to have a close affinity with the simplicity of the Cistercians. This text, written in the Umbrian dialect of the period, is quite innovative in its construction. It exudes a subtle interior richness. In the time of Francis, the troubadours and jongleurs were ardently creating the *chansons de geste*; at the same time legendary epics such as the tales of the Round Table and the quest for the Holy Grail were quite prevalent in the West. Imbued with this oral tradition, Francis composed his canticle as a song. The first manuscript of the canticle, which is preserved at Assisi, contains a number of lines left blank, and specialists are in agreement that these unused spaces were intended for notation of a musical score. Knowing this made working on this text a particular challenge for me—I wanted the calligraphed letters and colors to

suggest by themselves a melody. To make this ancient song resonate in a modern way while working with ancient scripts—this was the dare I tried to take.

To illustrate the "Canticle of the Sun" and the *Little Flowers*, I chose three scripts of the thirteenth-to-fourteenth centuries. The best known Italian script is Rotunda; this gothic script, round with pronounced serifs, is known in France as the script of the Summa, be-

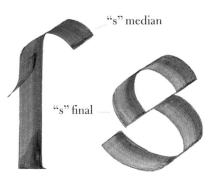

"s" median

"s" final

cause it was used to transcribe the *Summa Theologica* of Saint Thomas Aquinas. One letter is characteristic of this style, the *s*. The two ways it is formed, depending on whether it is a median *s*, distinguished by its elongated form, or a final *s*, might be confusing to the reader. I also made use of a late Carolingian script, a more compact script that prefigures the Rotunda, which was quite prevalent in the thirteenth century. Moreover, several rare autographs of Saint Francis of Assisi, written in the characters of this Carolingian script, are extant. The characters, however, appear deformed in the autographs on account of the stigmatized hand of the poverello. Finally, I made use of Italian inclined script, the last calligraphic creation of the Middle Ages, from which a more cursive style develops. Italian in its medieval version fascinates me just as much as ancient French or ancient Flemish, because of

the musicality of all of these languages. As for the colors, I honored this same spirit by painting in typical Italian tonalities: raw sienna, burnt sienna, umber, Venetian red, Verona green, lime white, and other colors one finds in the soil of Italy, which include the colors of Burgundian stone. Using materials such as stone, lime, paper, cardboard, or even burlap, I created backgrounds that I would qualify as "poor." These are simple substances, which, however, are rich in texture, and they seem to me to correspond well to the mind of Francis of Assisi.

In studying the works of antiquity or the Middle Ages, we can see that the artists of those times understood perfectly the laws of optics that govern calligraphic creation. Nowadays, however, many calligraphers seem to have forgotten these basic principles. If the eye has not been educated, strokes lack force, contrast, and rhythm. A great number of apprentice calligraphers launch themselves without adequate training into the commercial space that has been created by the current enthusiasm for this art. But whatever a person's talent, it is

impossible to improvise oneself as a calligrapher. If there is one piece of advice that should be given to those who wish to become adepts of the art of the stroke, it is found in these words that Claude Mediavilla is fond of repeating: "The rule is to be taught in a rational manner by competent masters."

Frank Missant

Frank Missant